# INFINITE ILLUSIONS
## COLORING BOOK

### Eye–Popping Designs on a Dramatic Black Background

## JOHN WIK

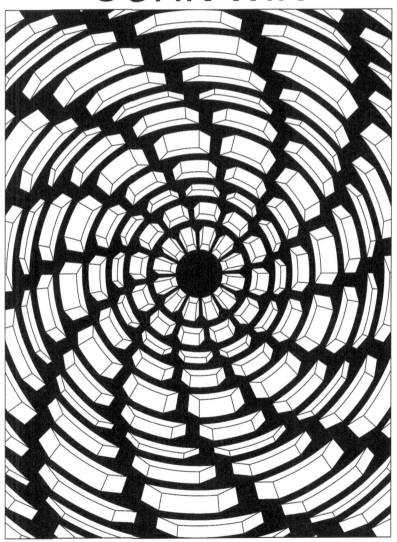

## DOVER PUBLICATIONS
### GARDEN CITY, NEW YORK

These unique and exciting designs feature several shapes—a variety of circles, swirls, and angles—in dynamic, mesmerizing patterns. The looped, woven, and high-contrast images will provide the experienced colorist with many opportunities for imaginative experimentation with different media techniques and color schemes, and the perforated, unbacked pages make it easy to display finished work.

*Bibliographical Note*

*Infinite Illusions Coloring Book* is a new work, first published by Dover Publications in 2016.

*International Standard Book Number*

*ISBN-13: 978-0-486-80713-3*
*ISBN-10: 0-486-80713-4*

Manufactured in the United States of America
80713403
www.doverpublications.com

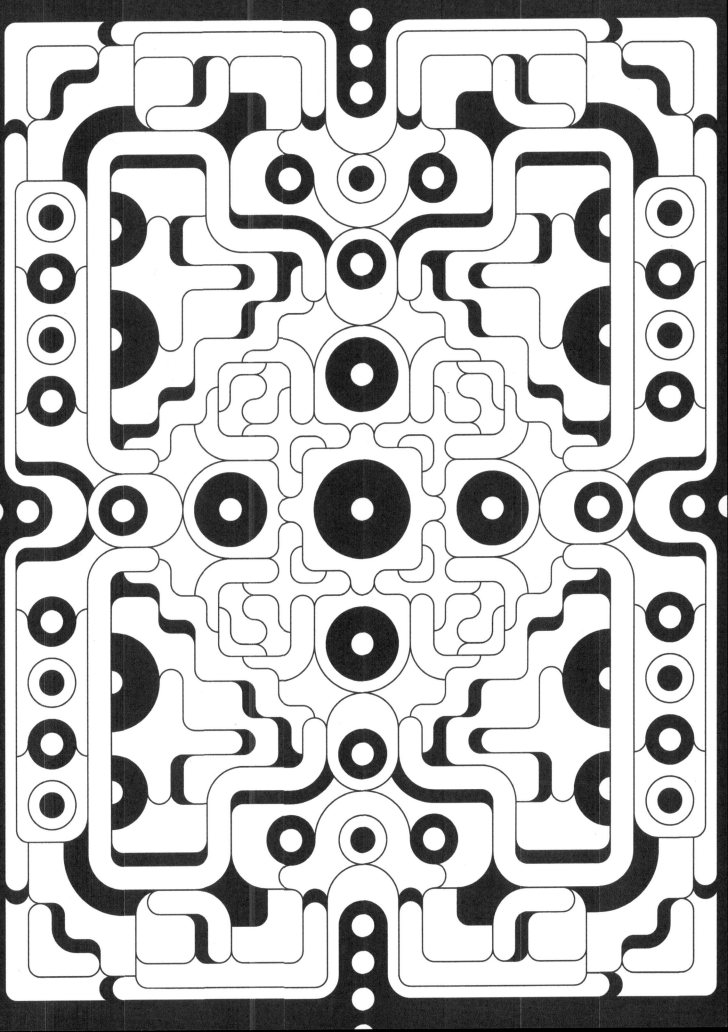

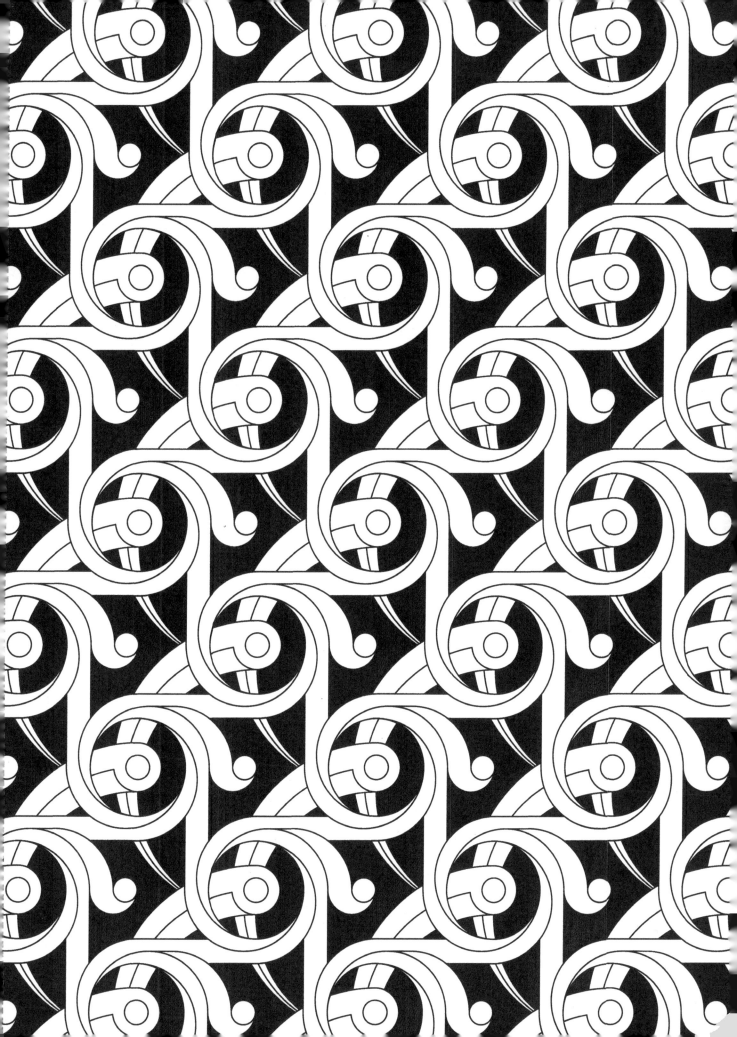

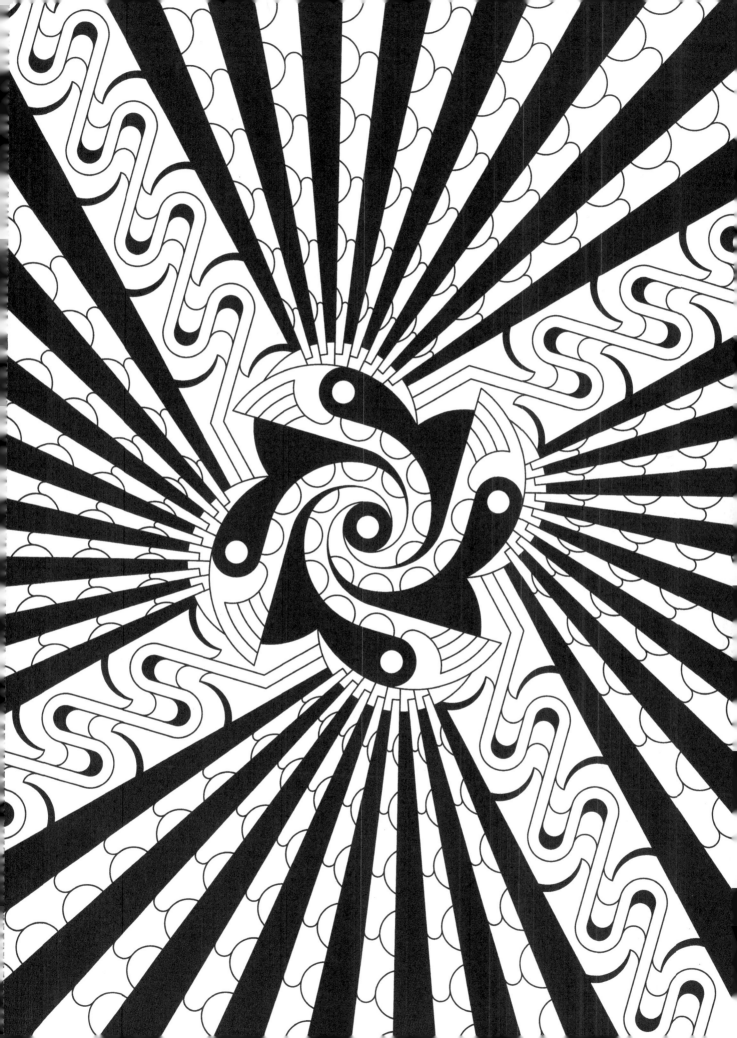

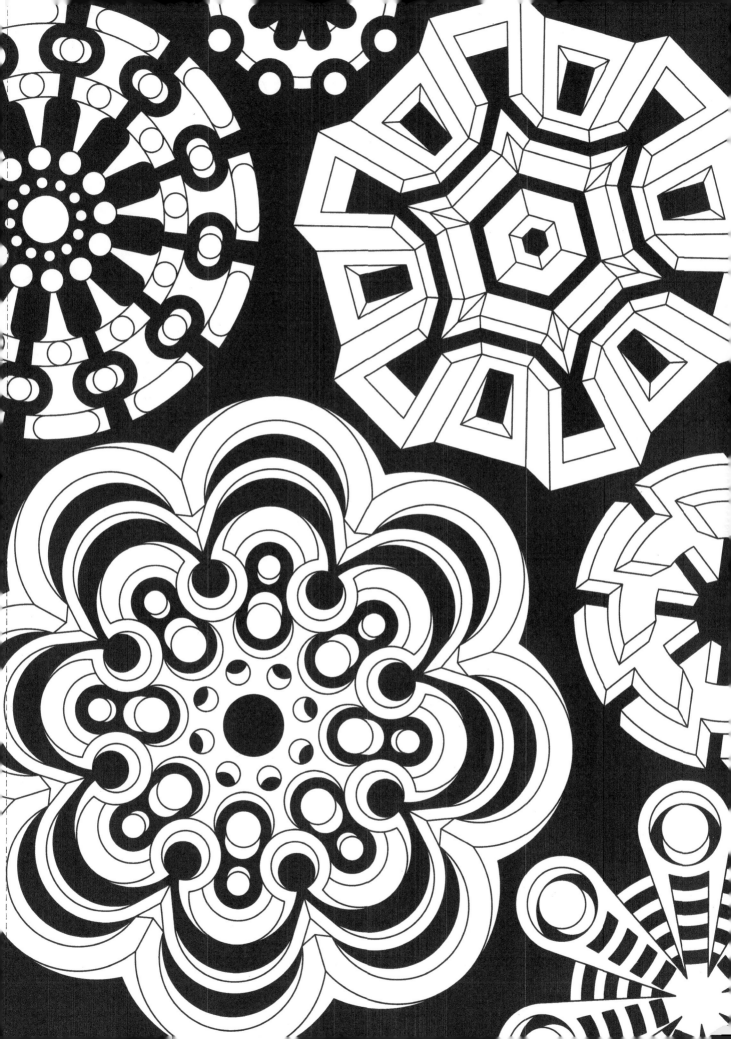

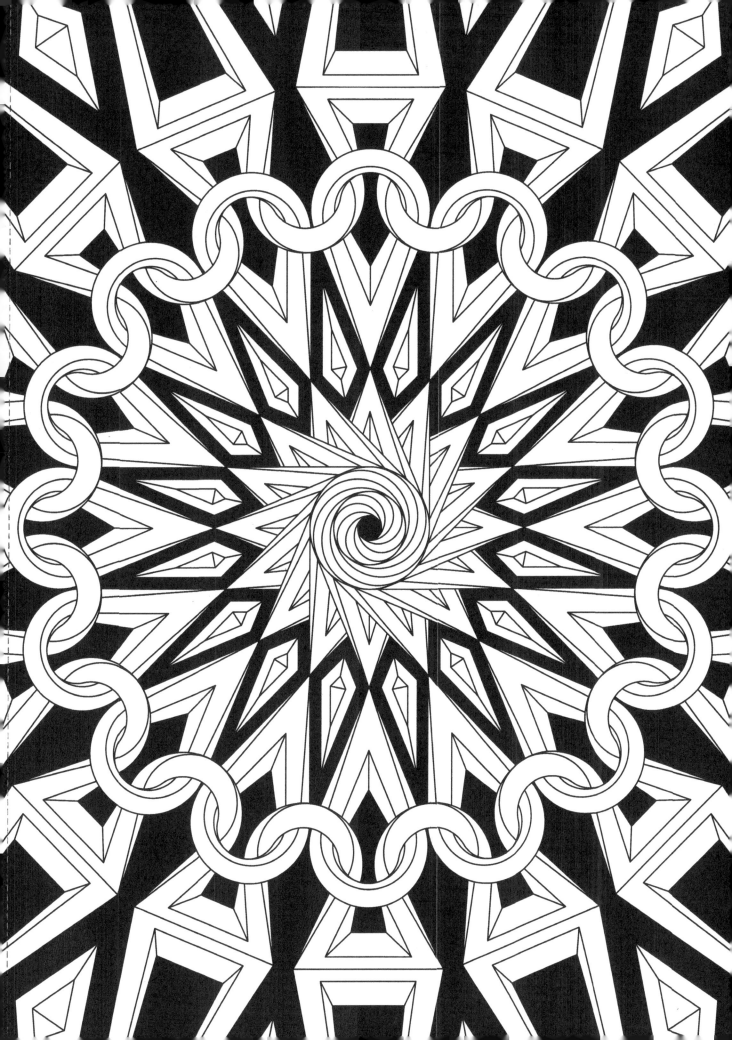

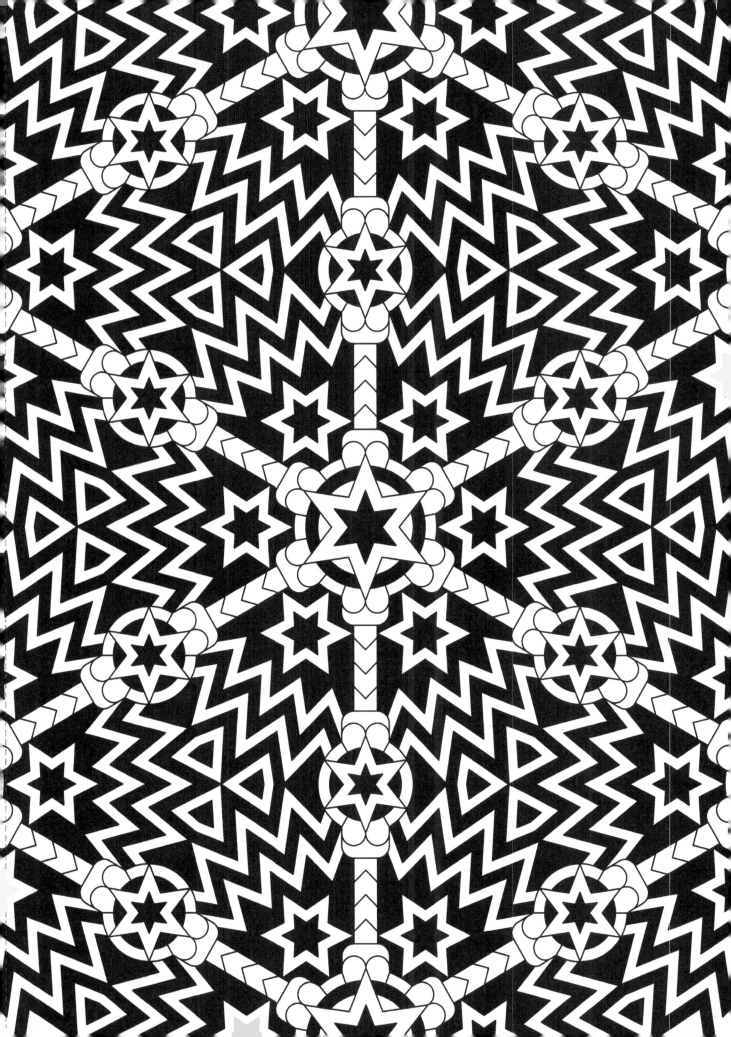

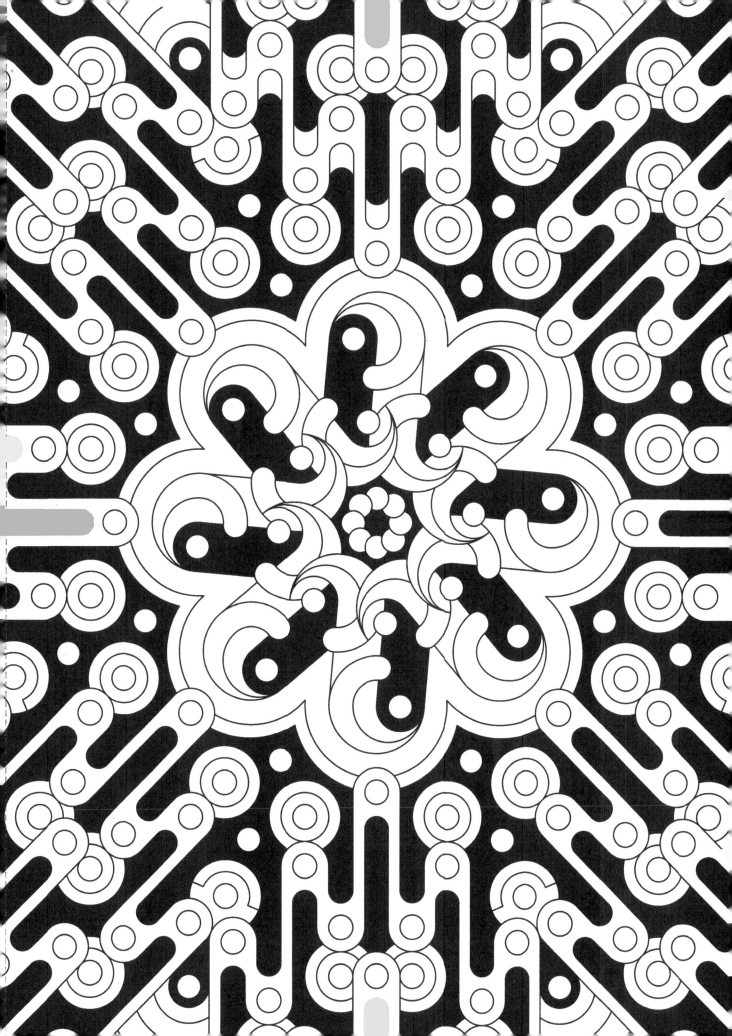

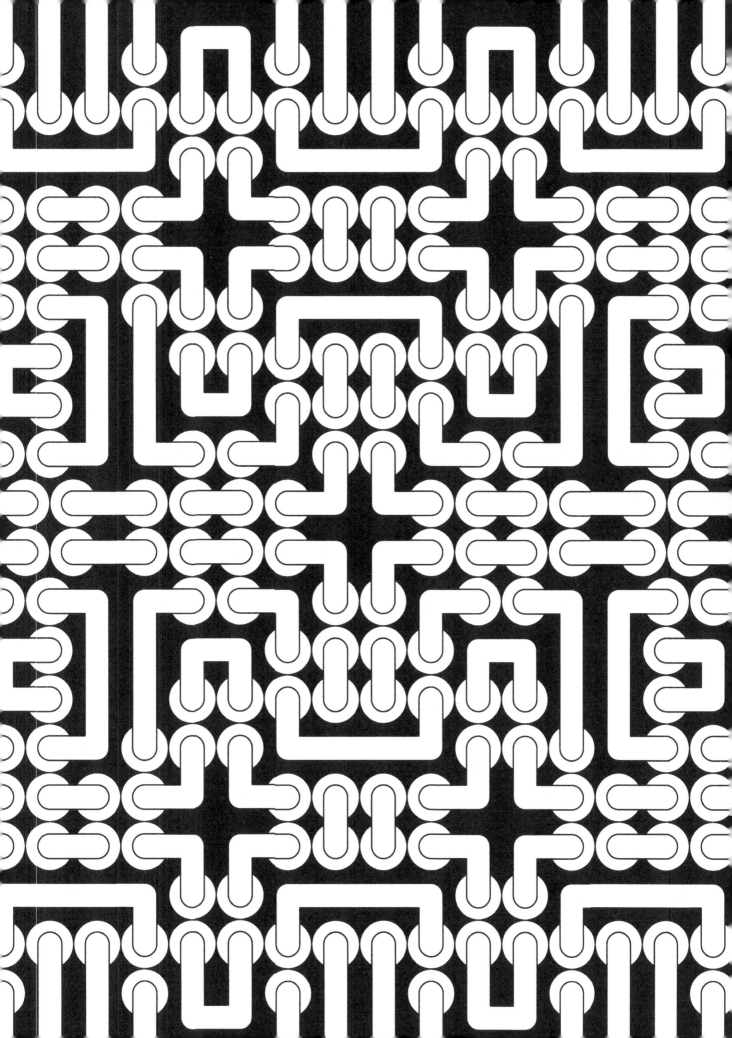

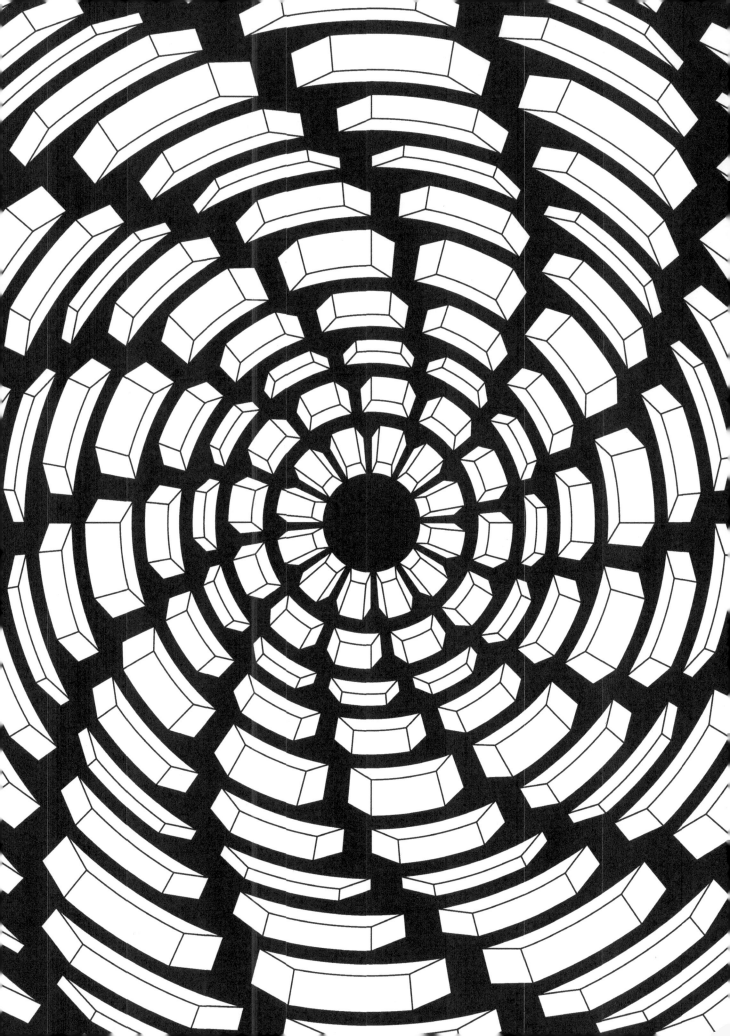

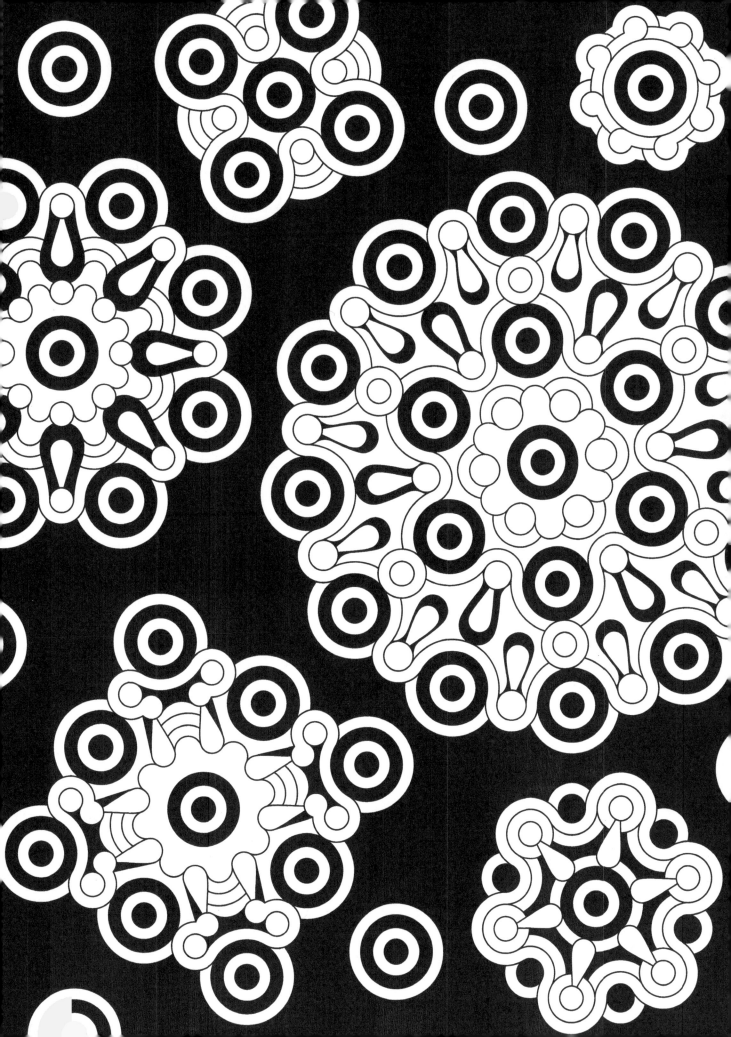

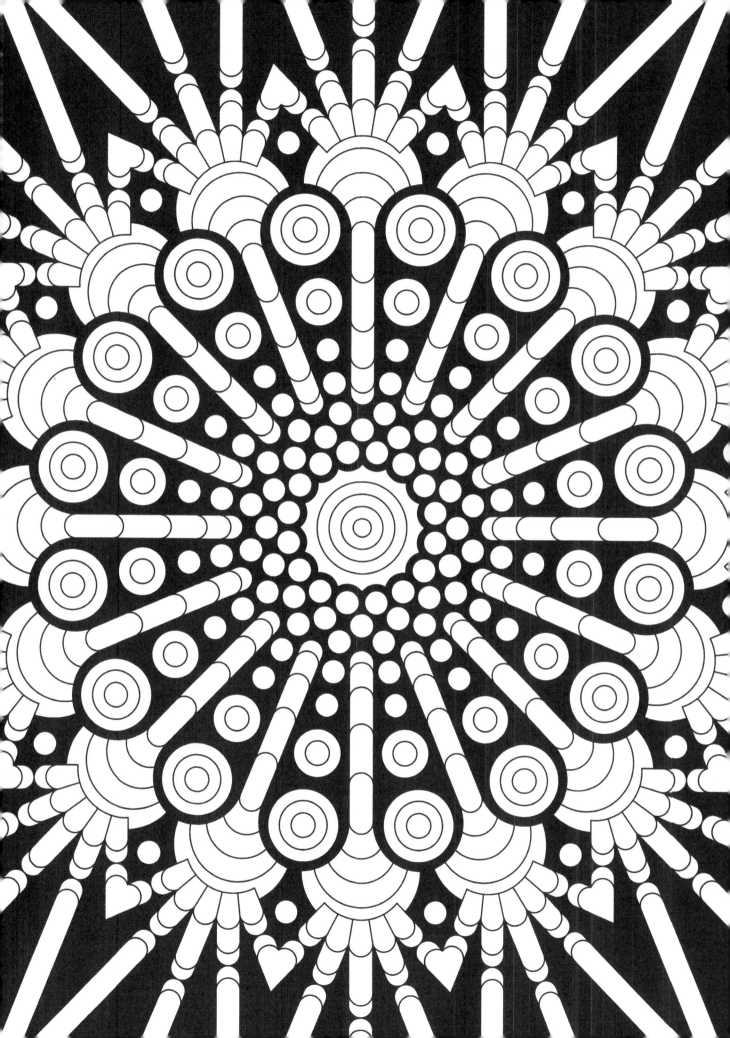

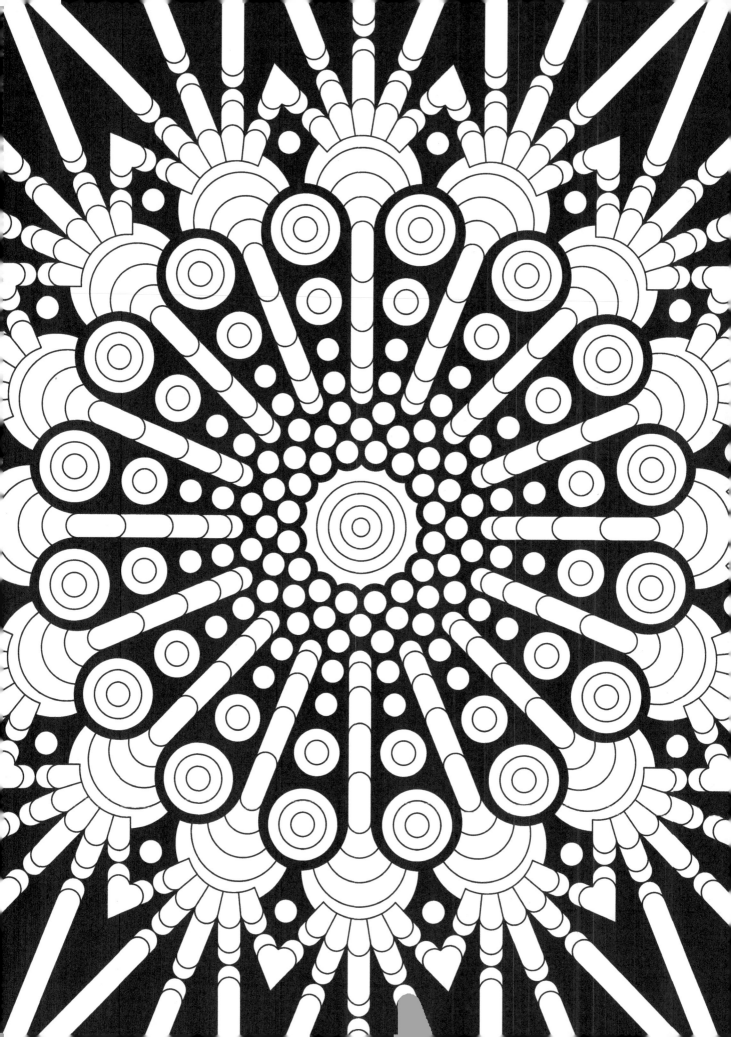

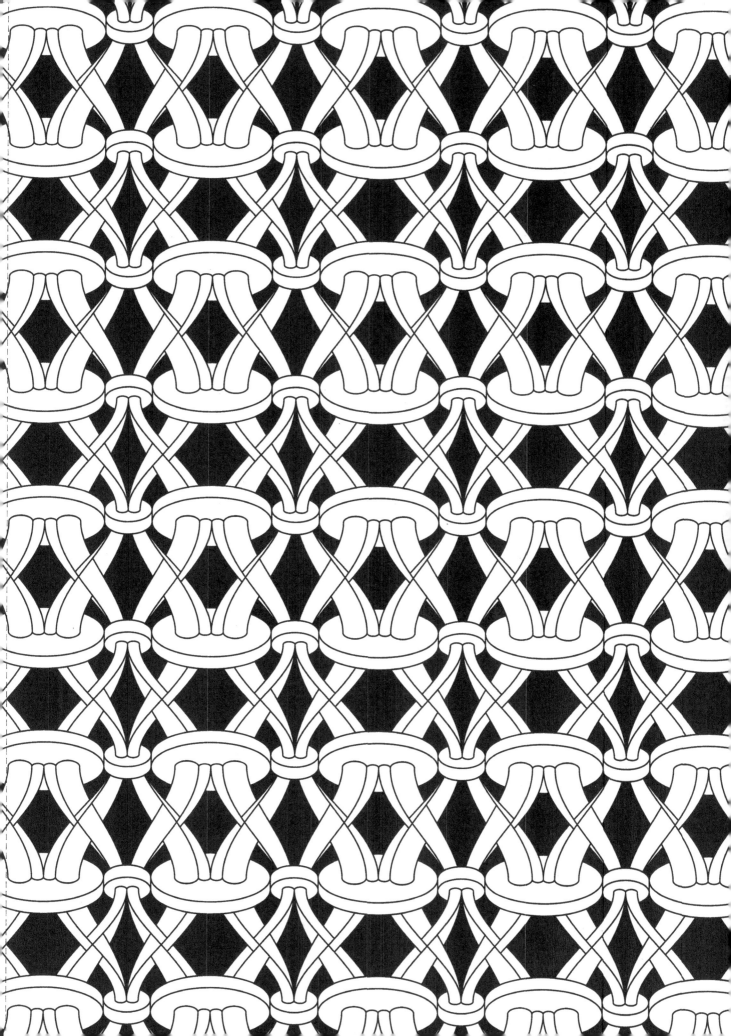

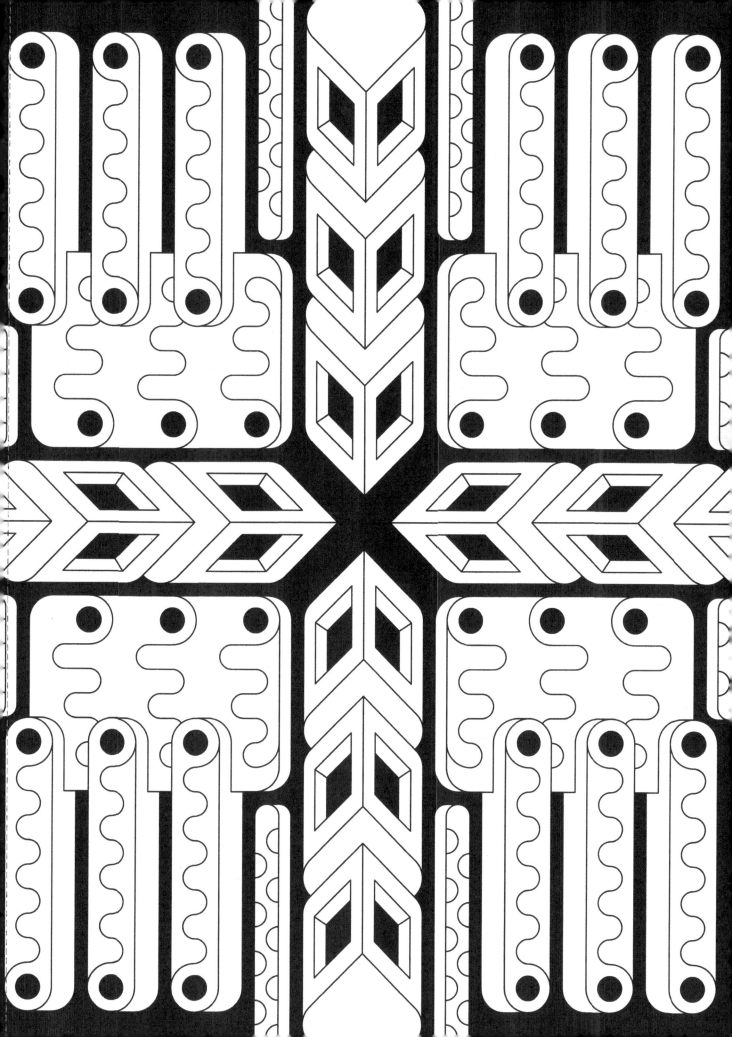

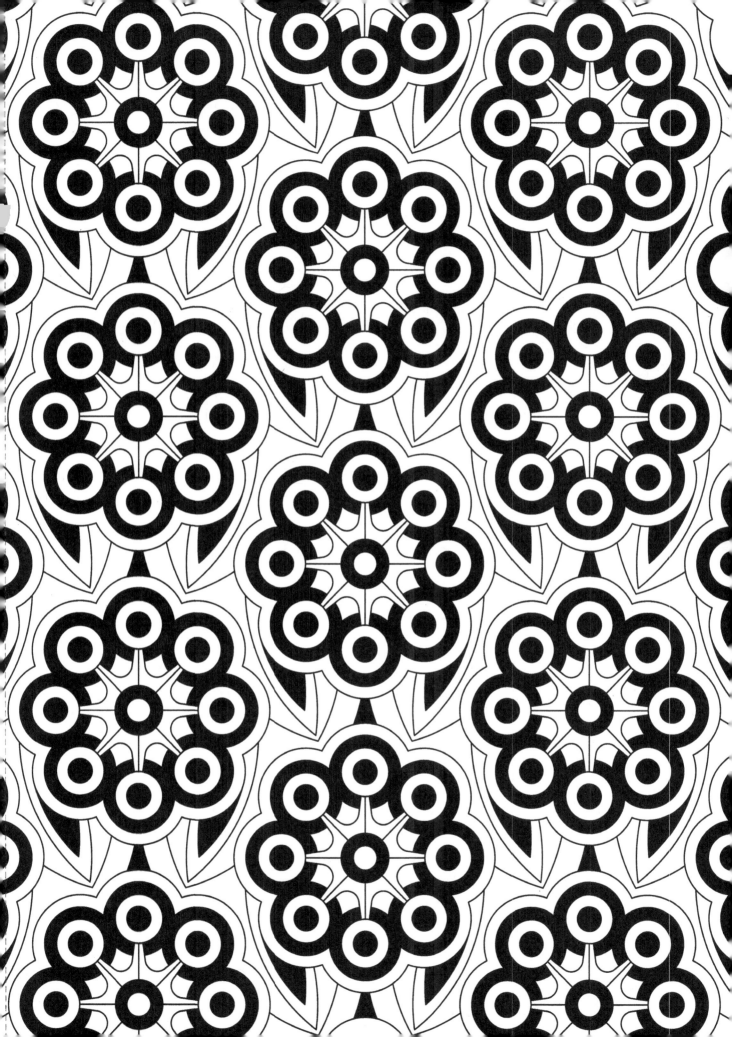

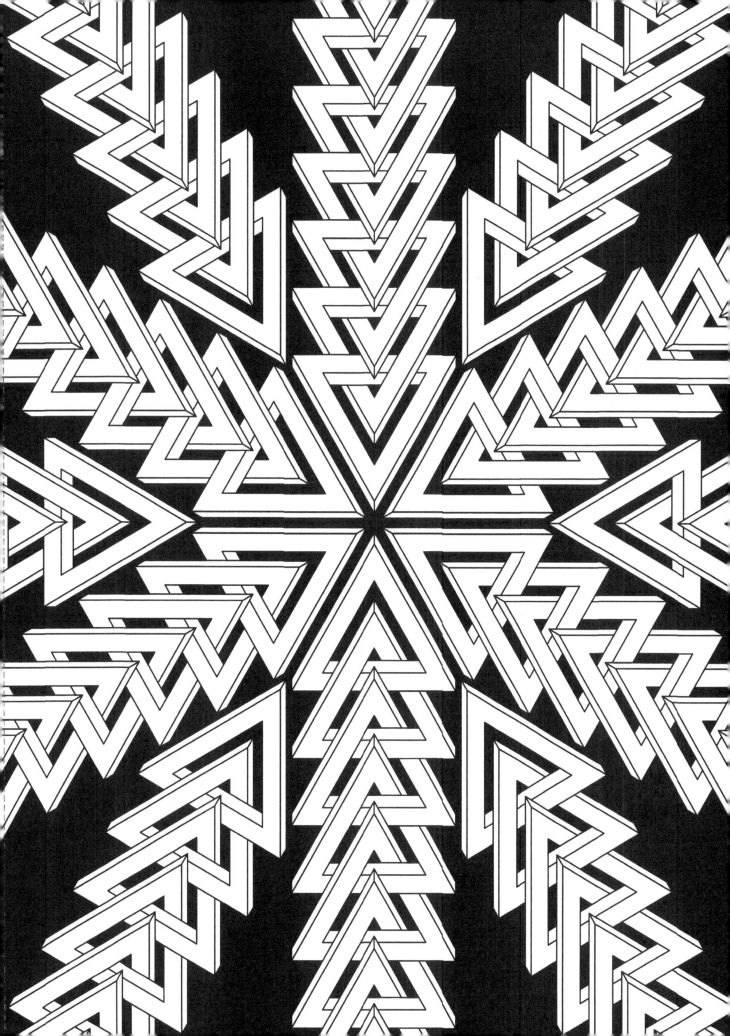

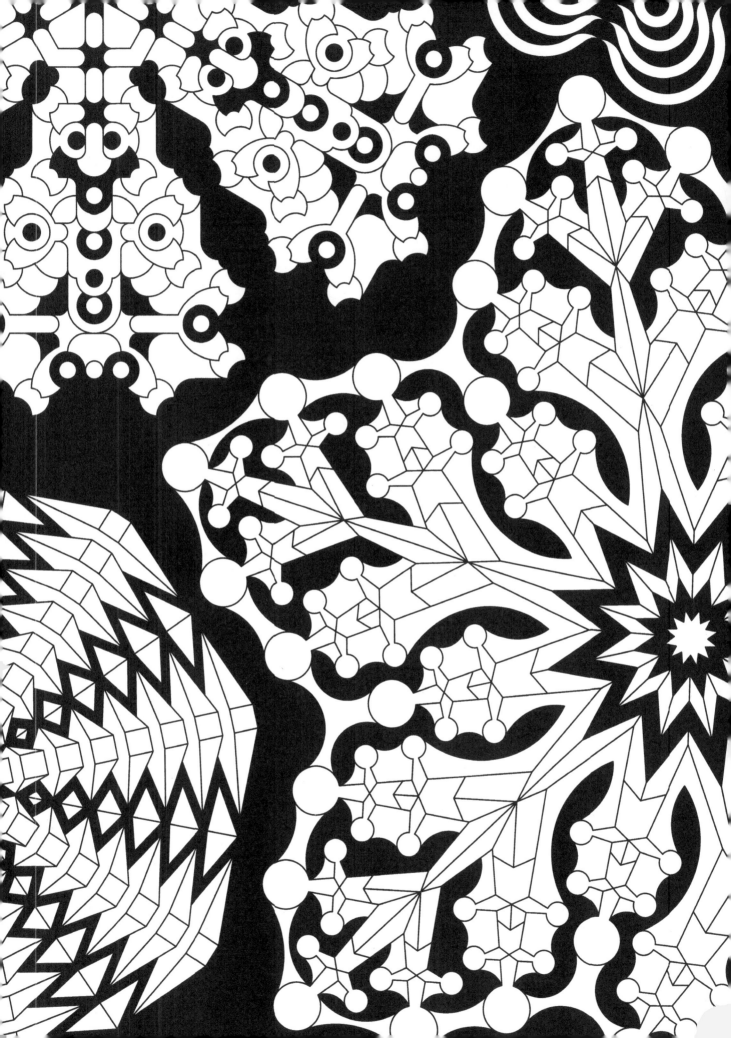

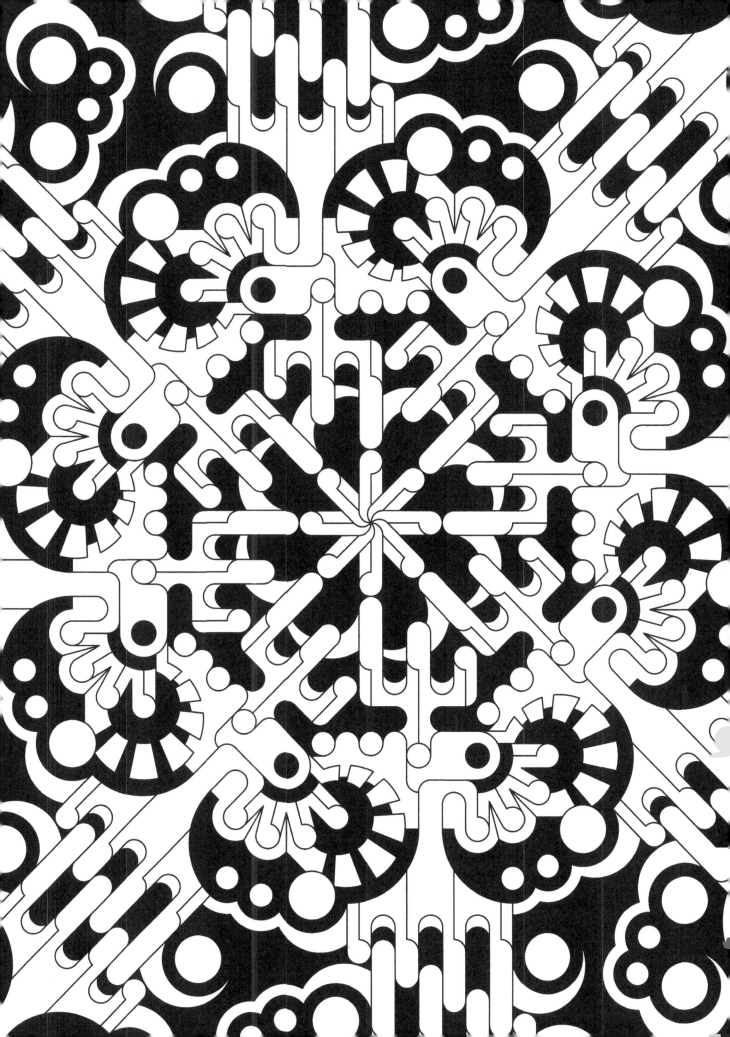

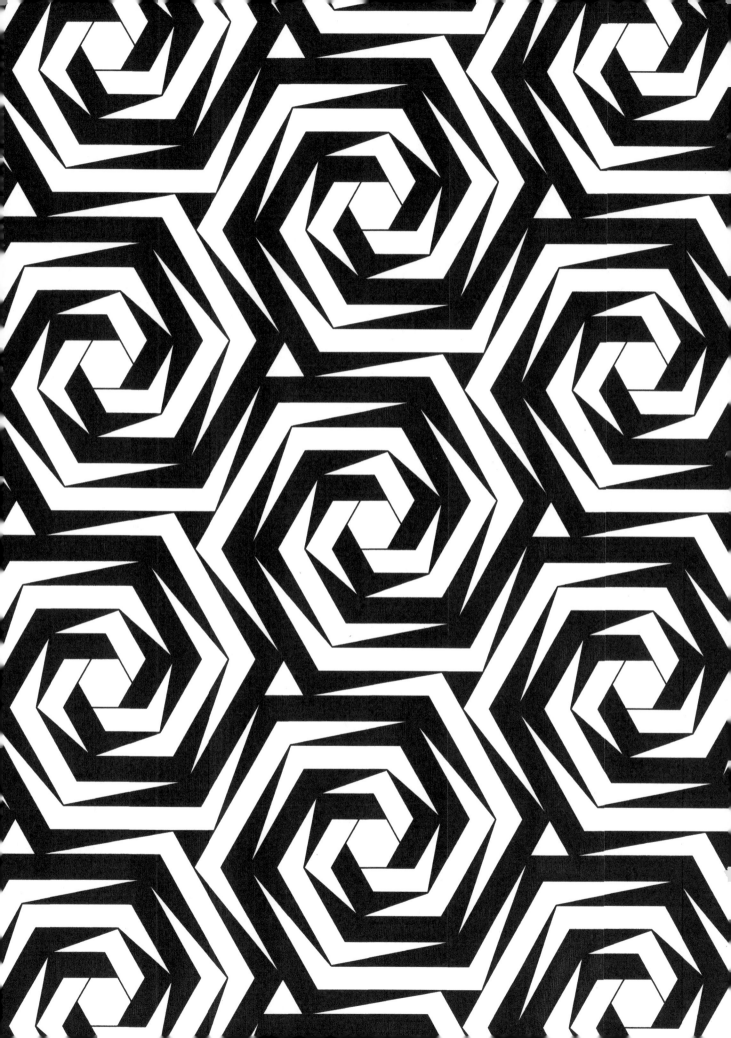

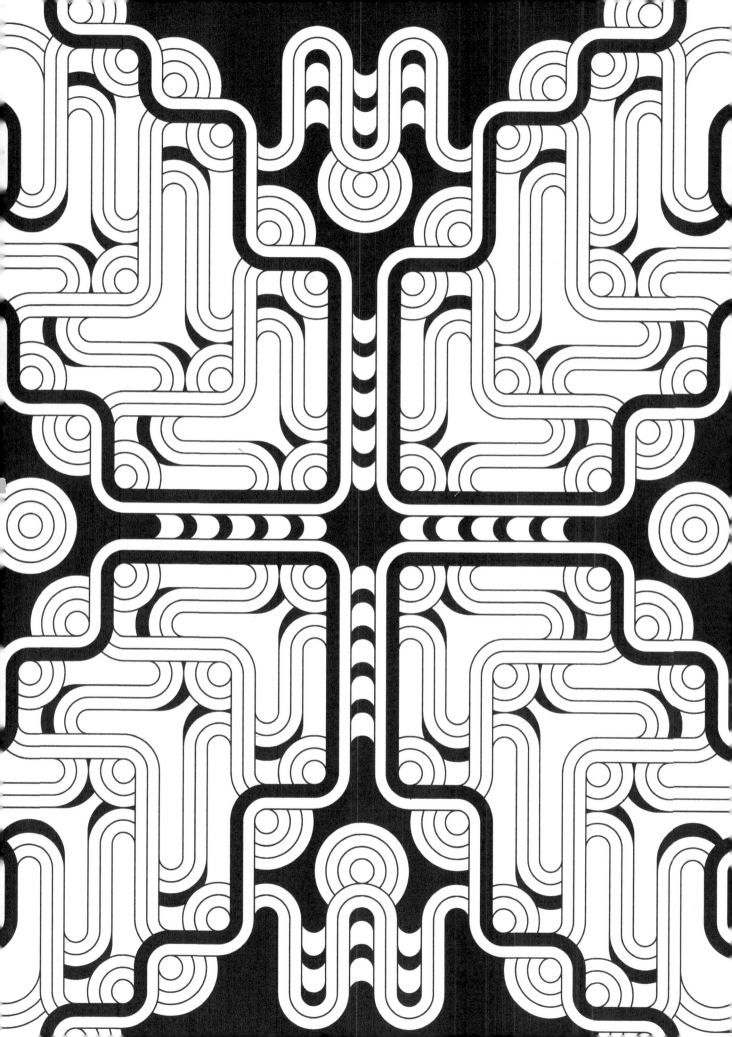

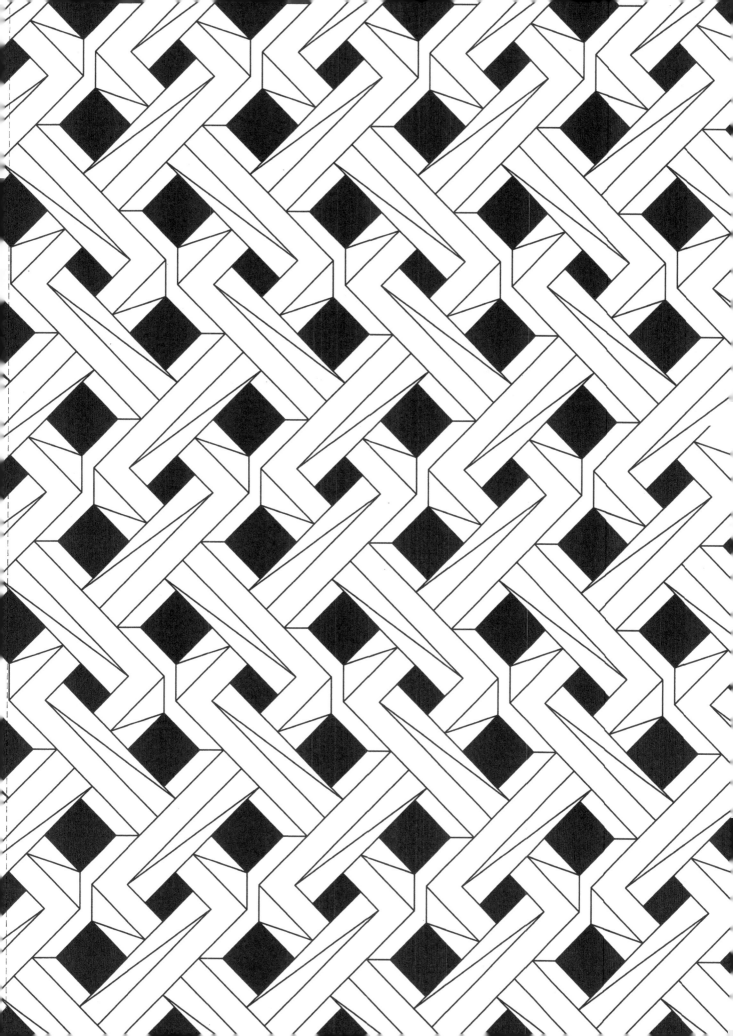

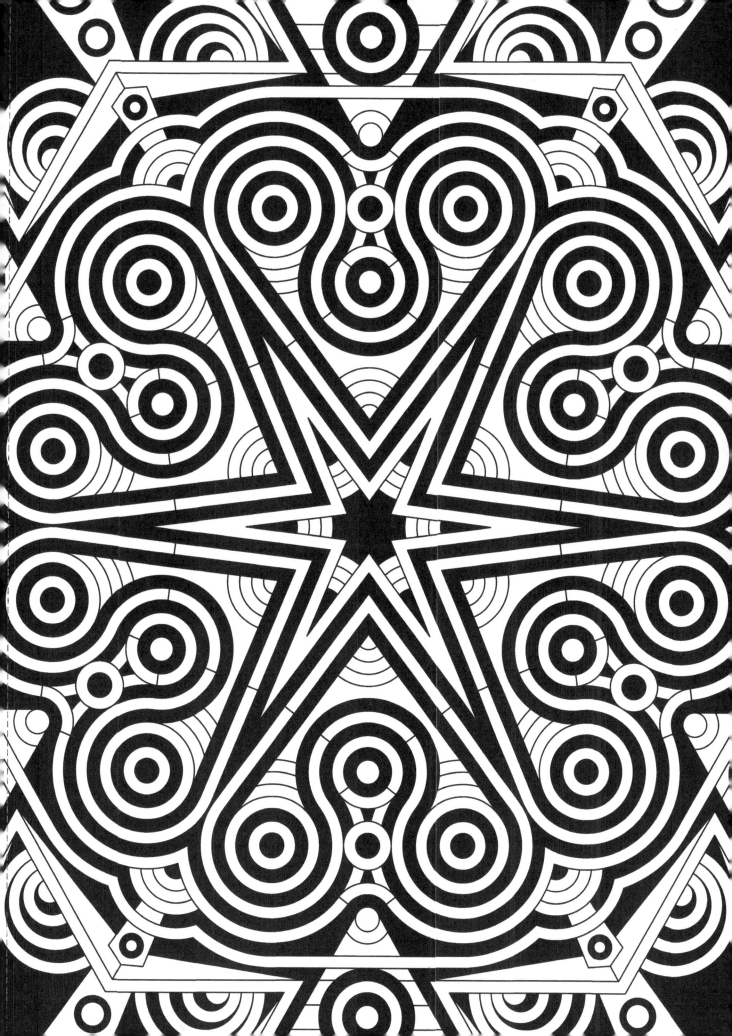

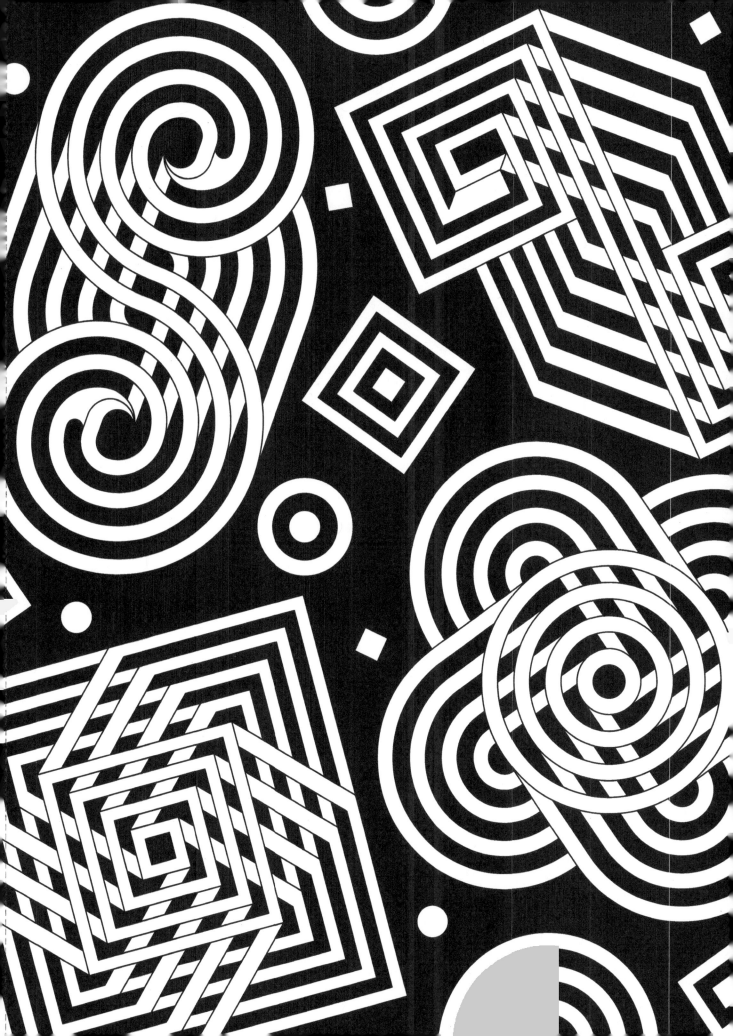

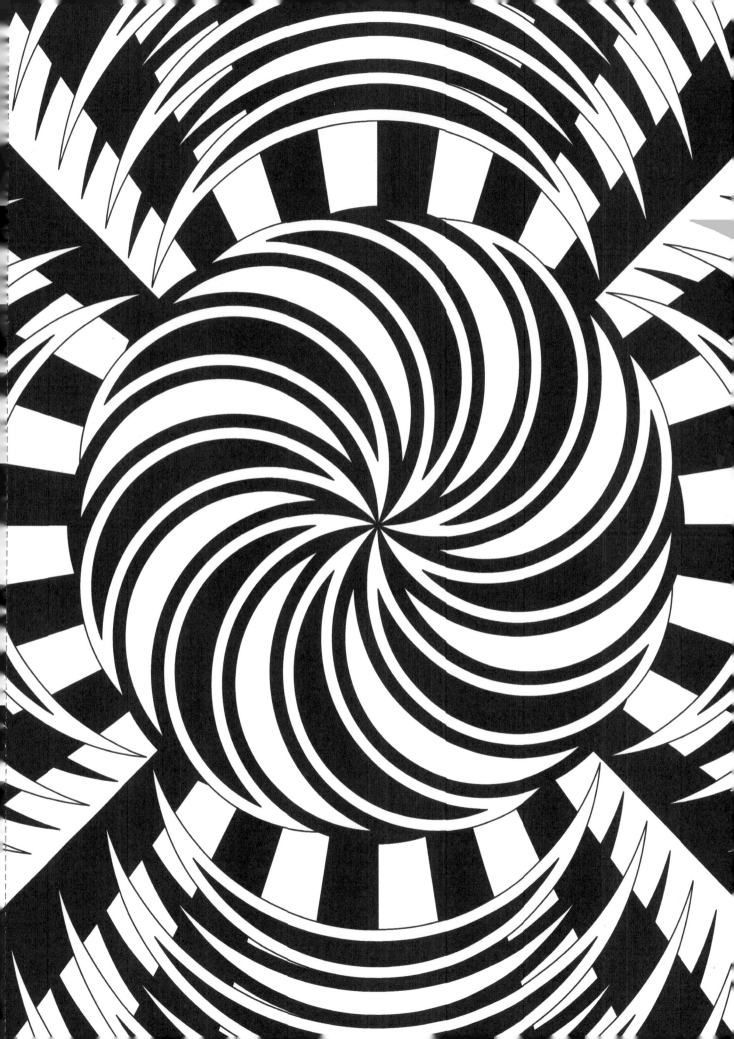

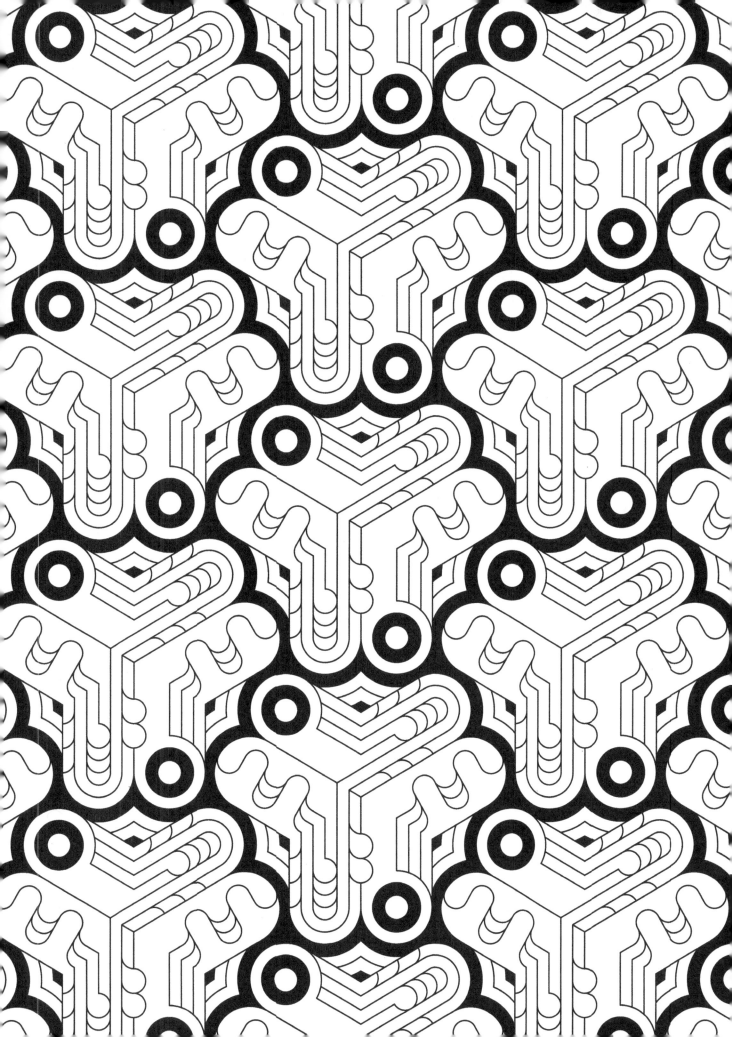

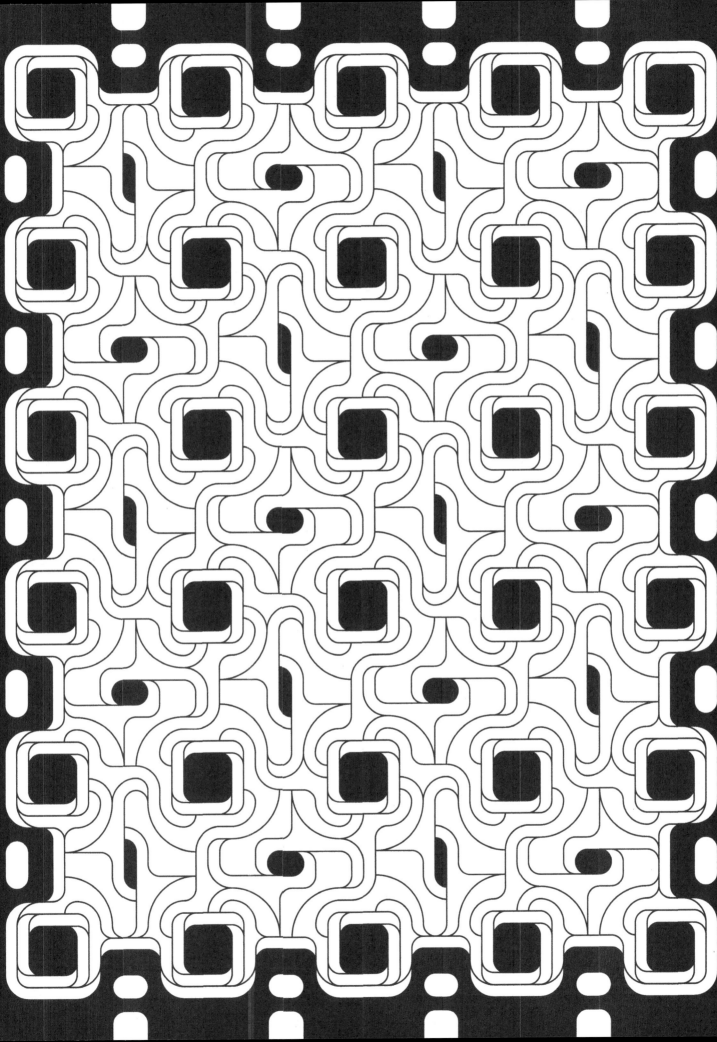

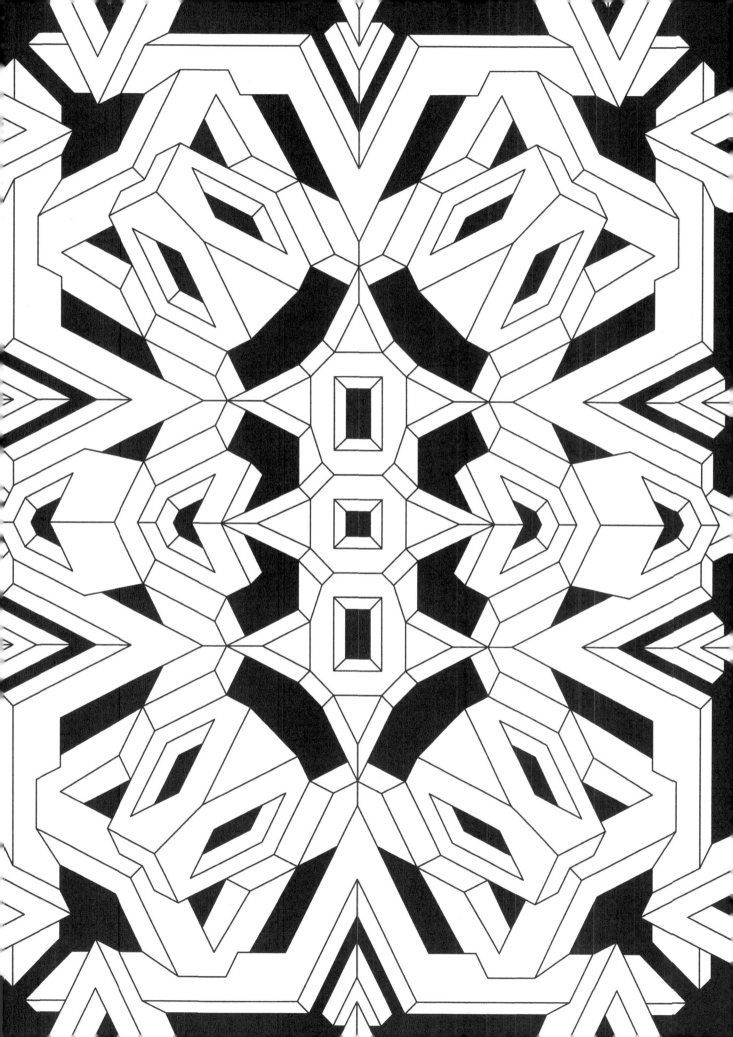

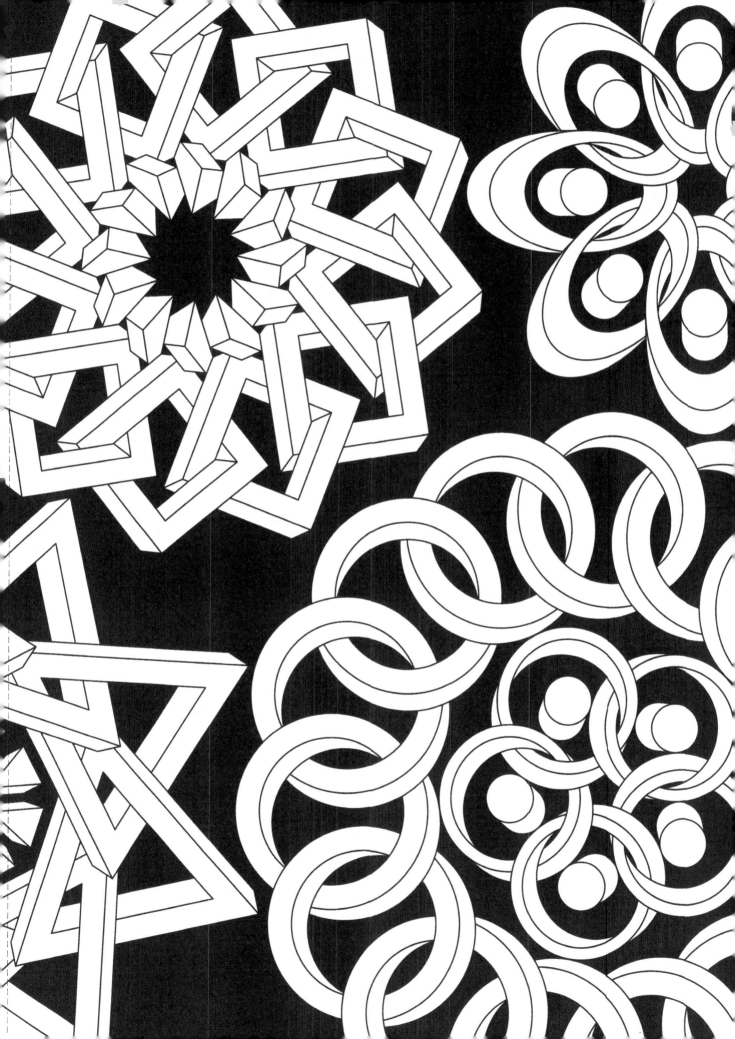

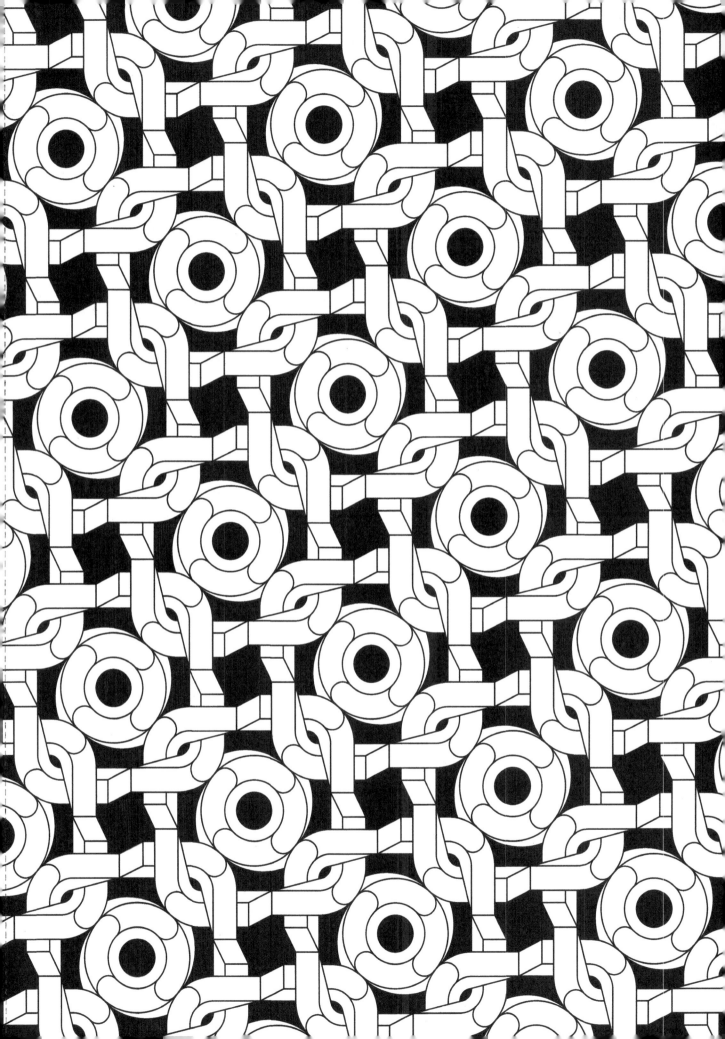

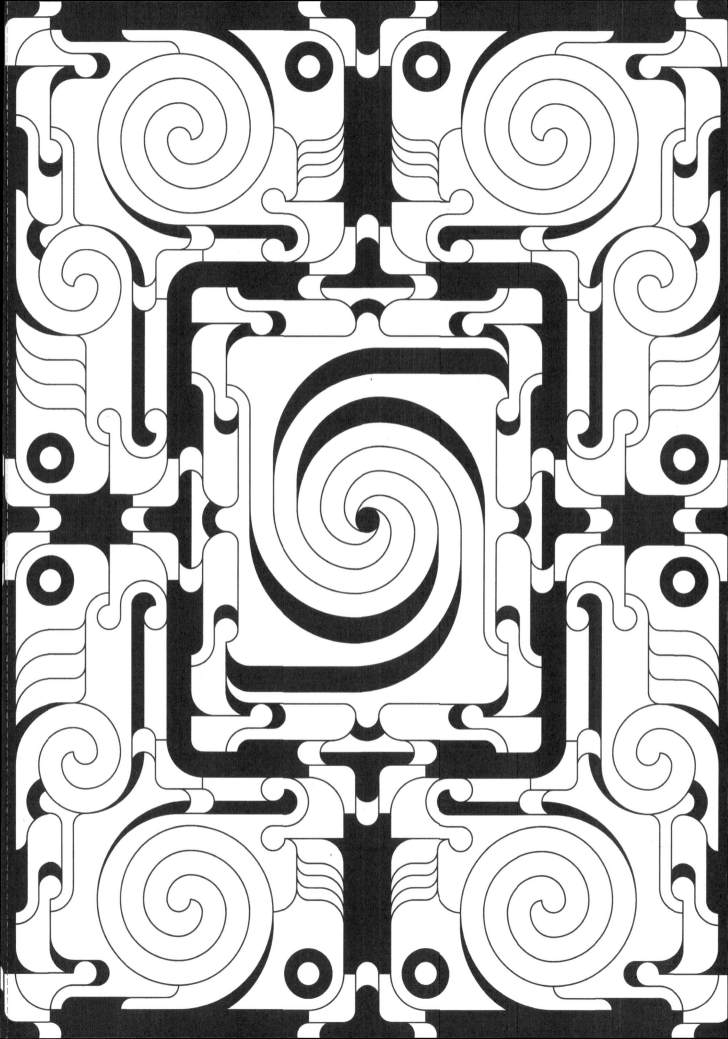